DE-STRESS AND COLOR PEOPLE

Volume 1

Copyright 2016 Ubertec Publishing
Original Photographs CC0 pixabay.com

No Reproduction of This Book Authorised Without Permission

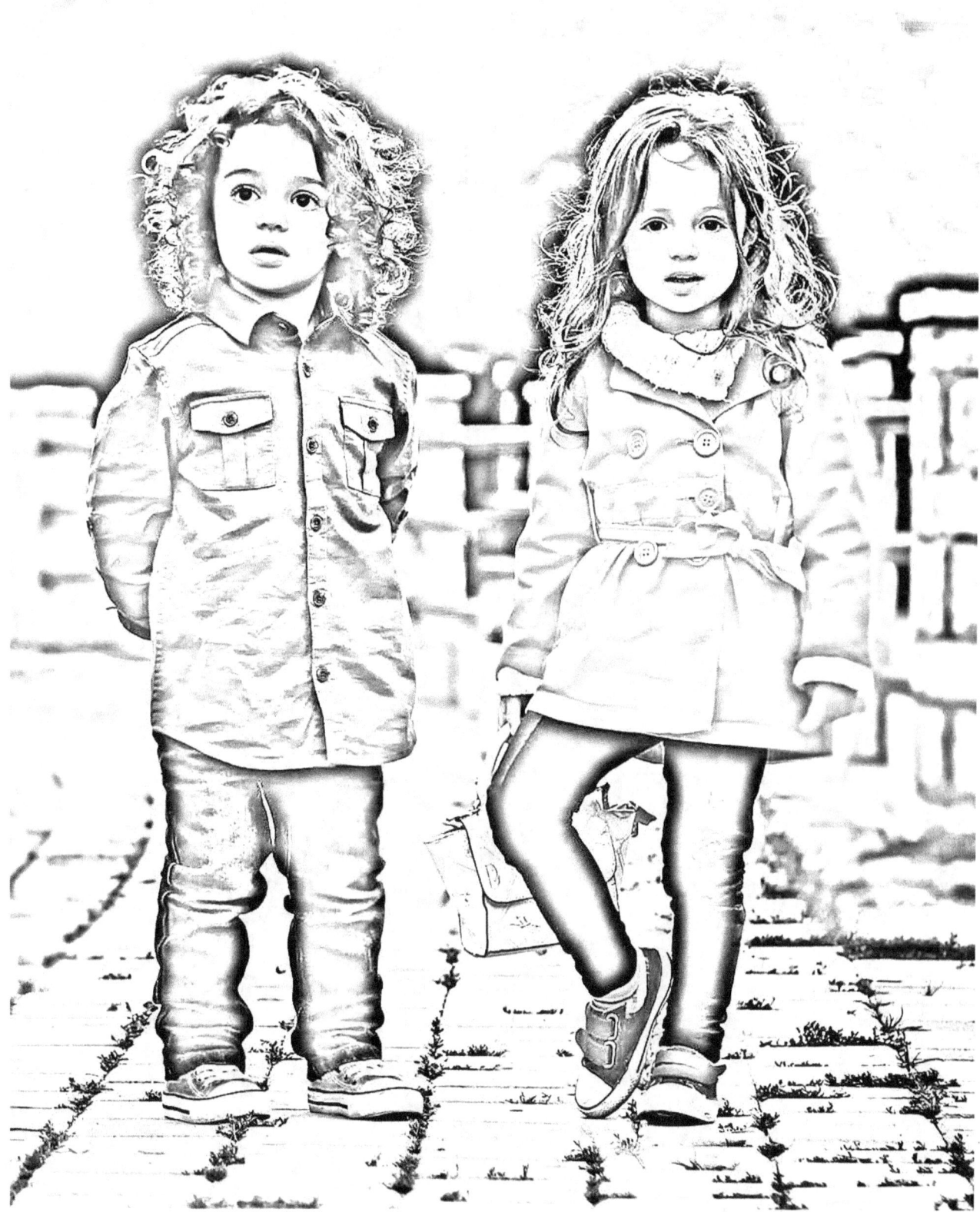

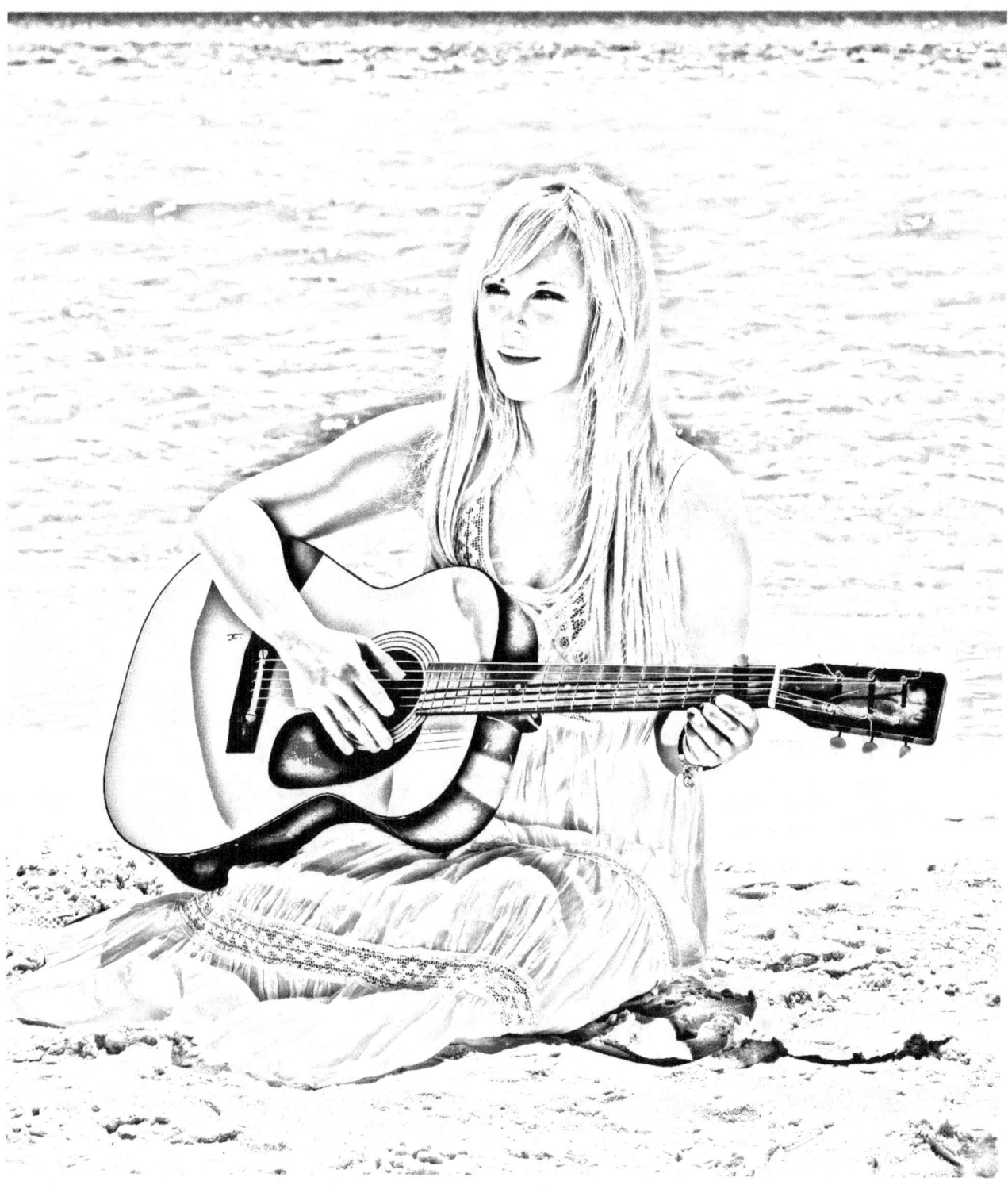

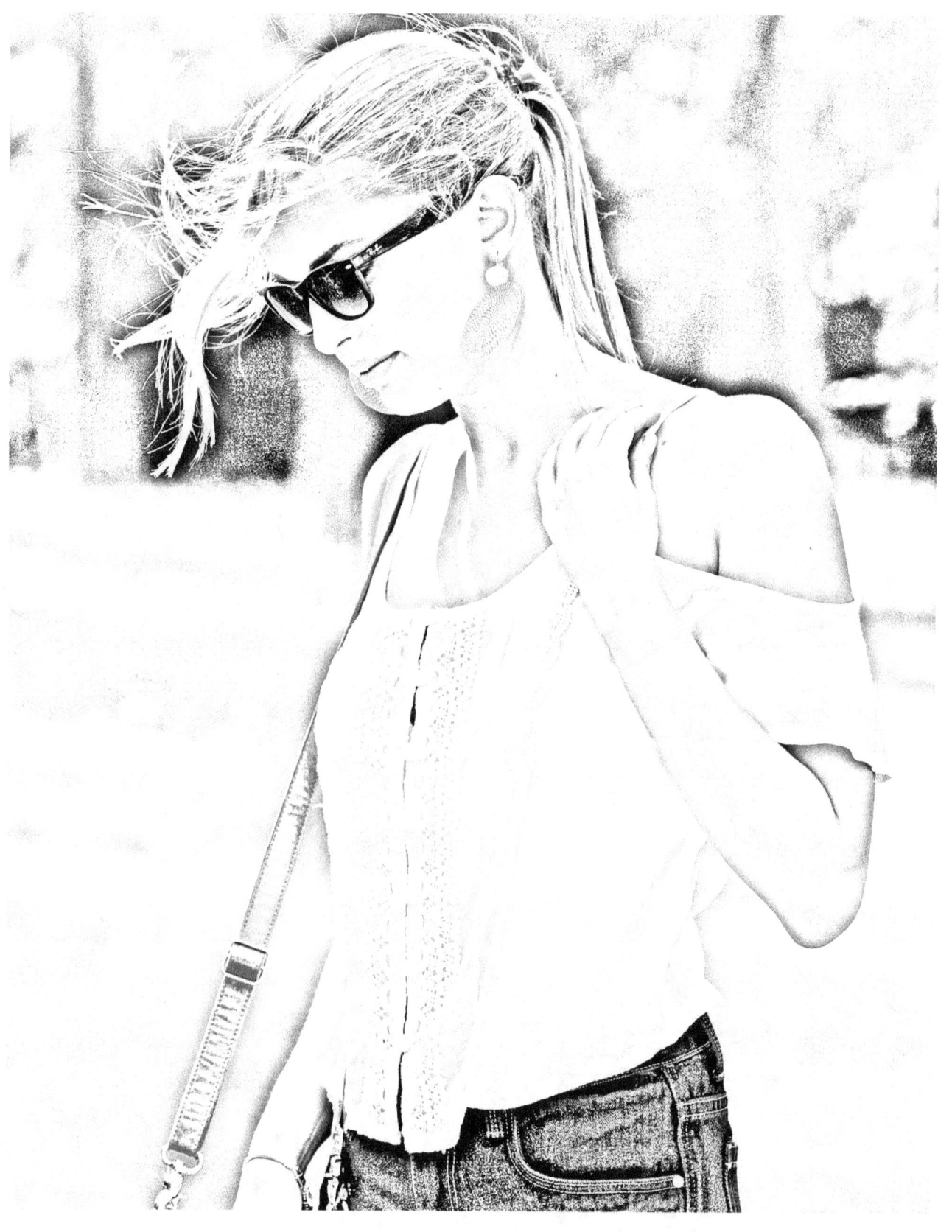

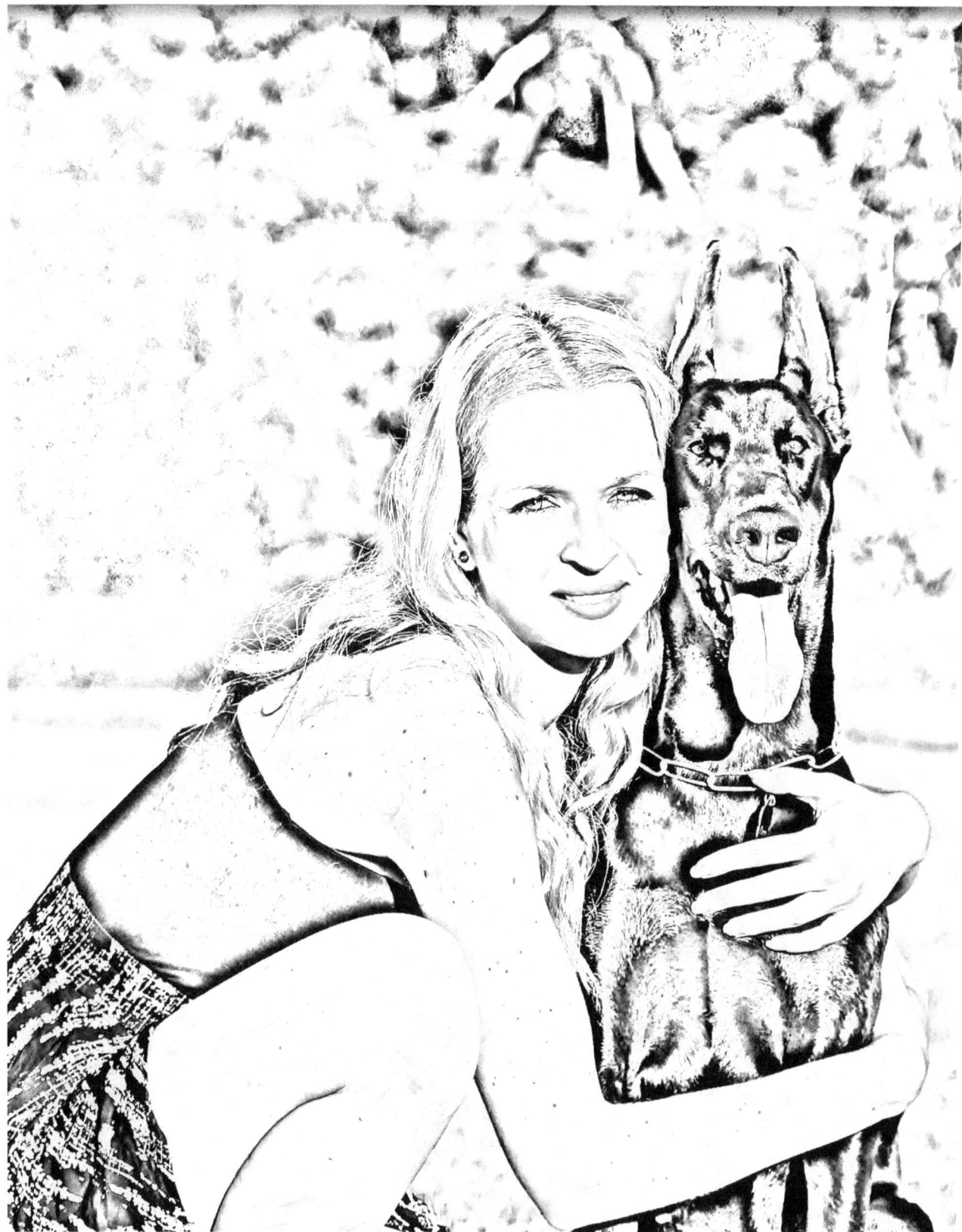

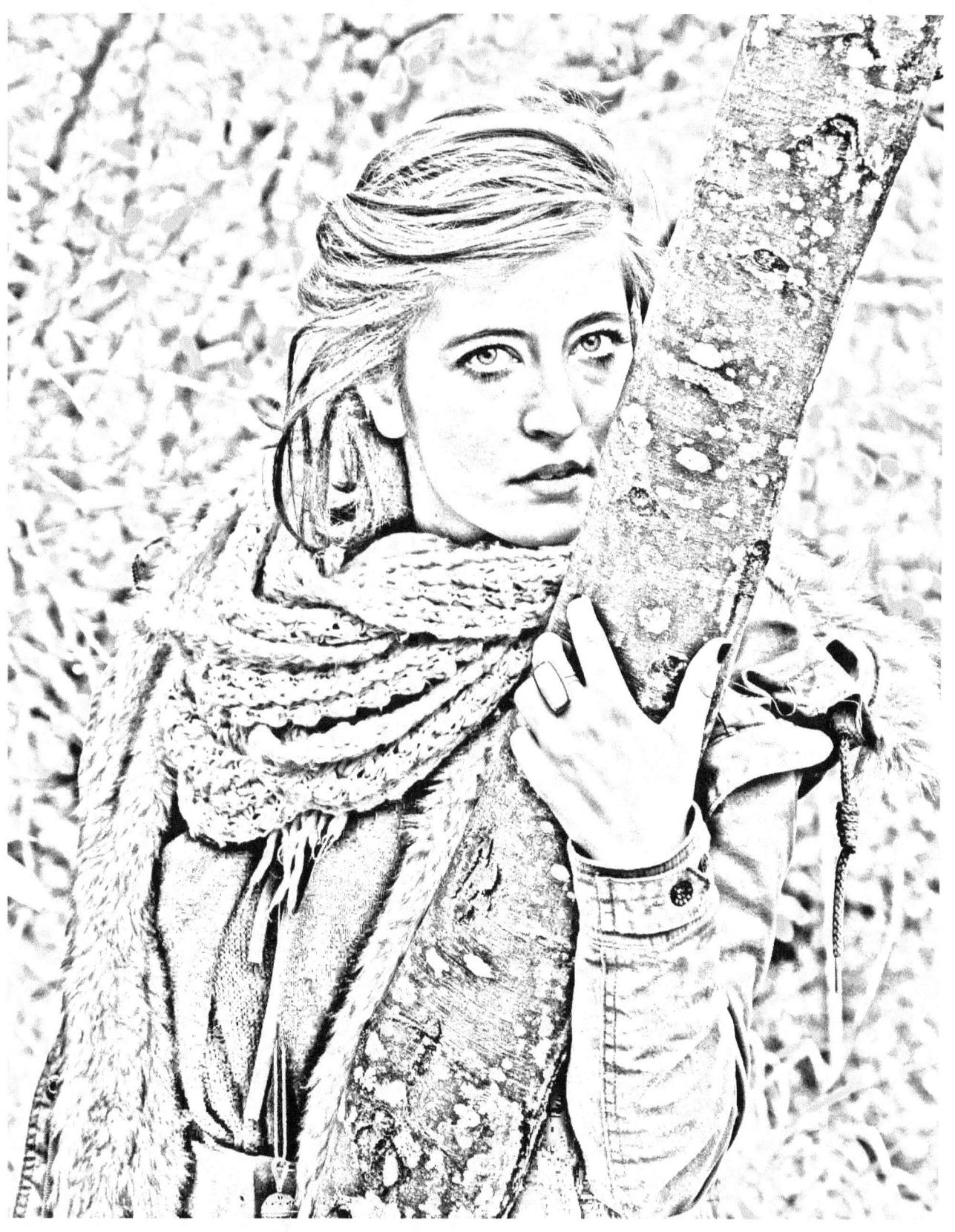

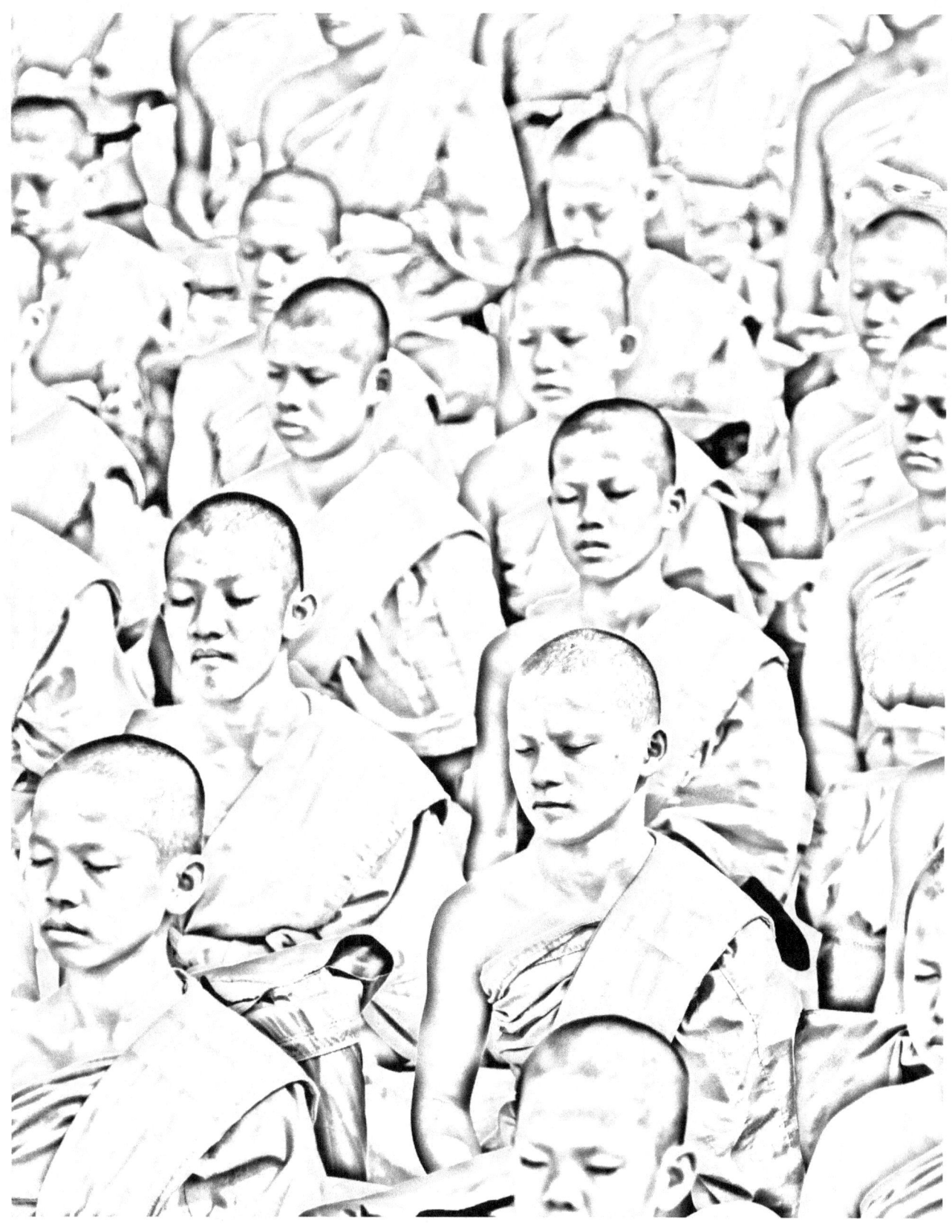

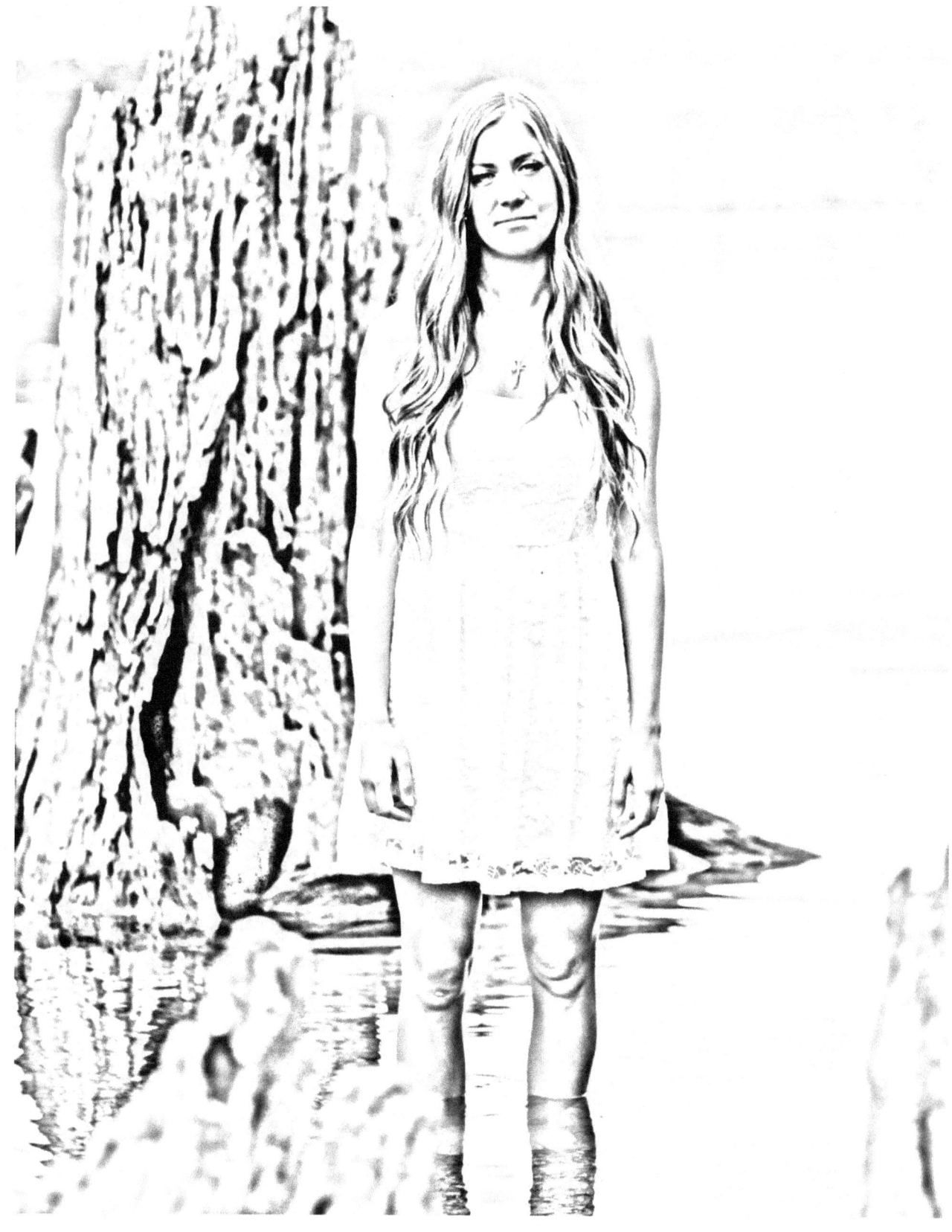

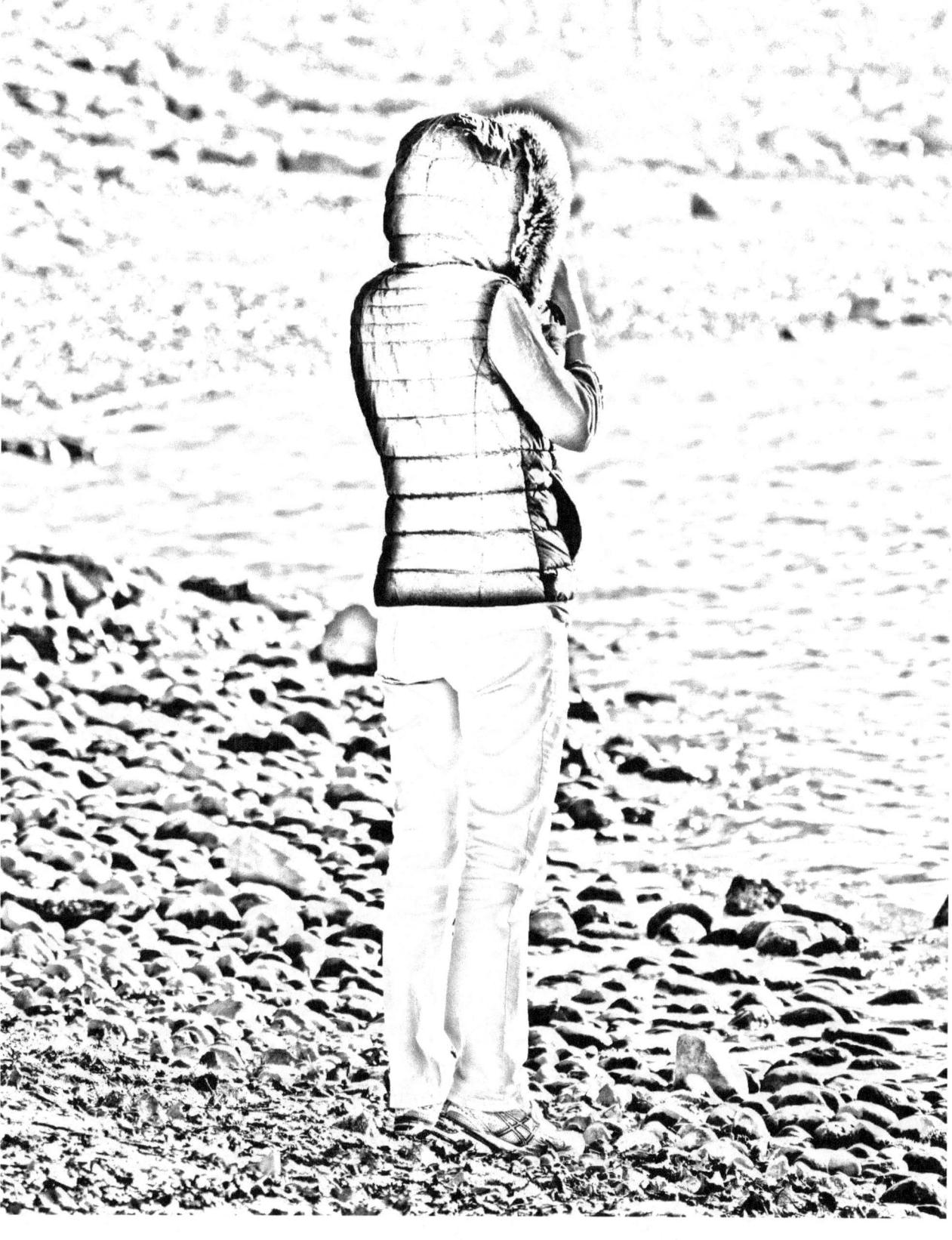

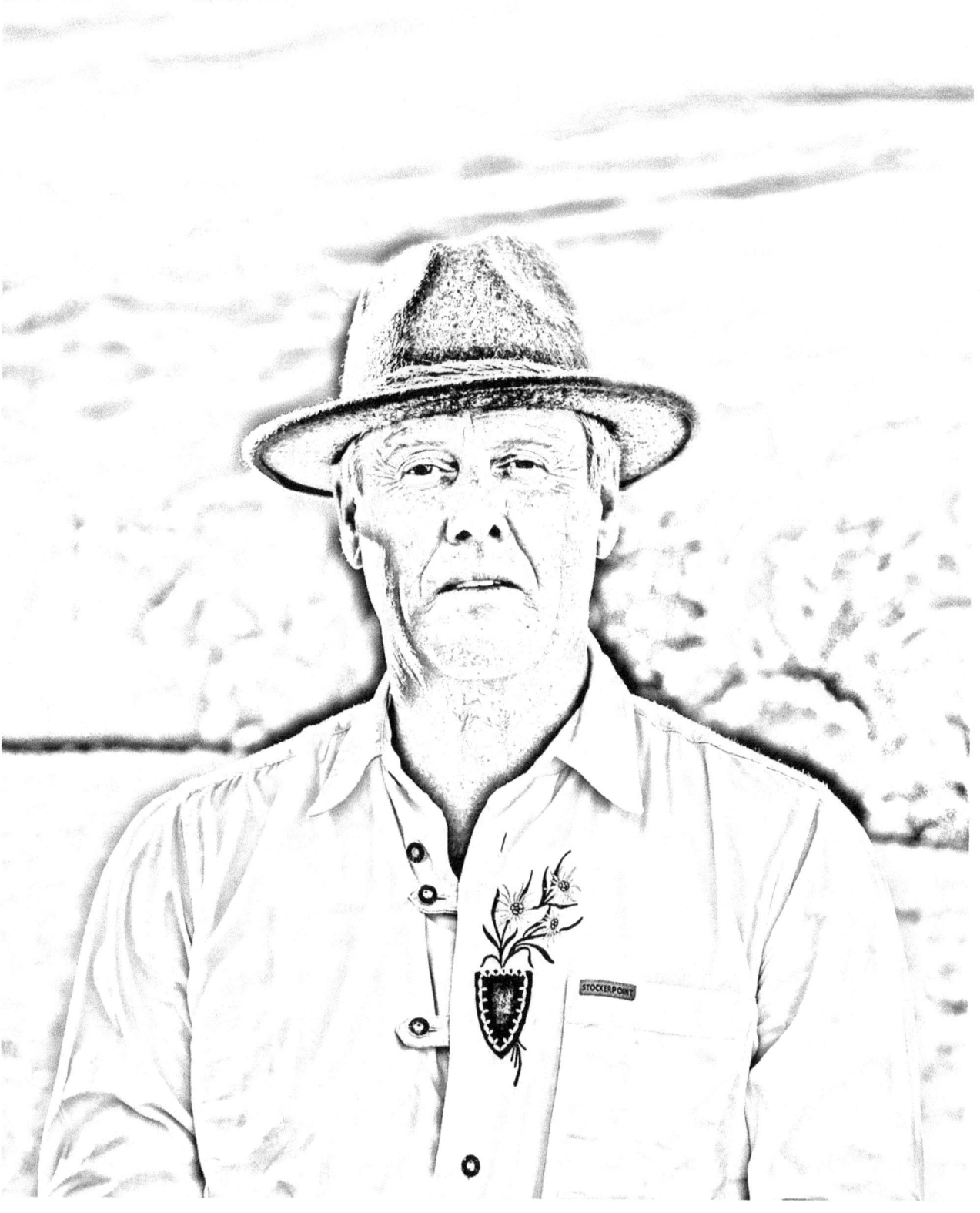

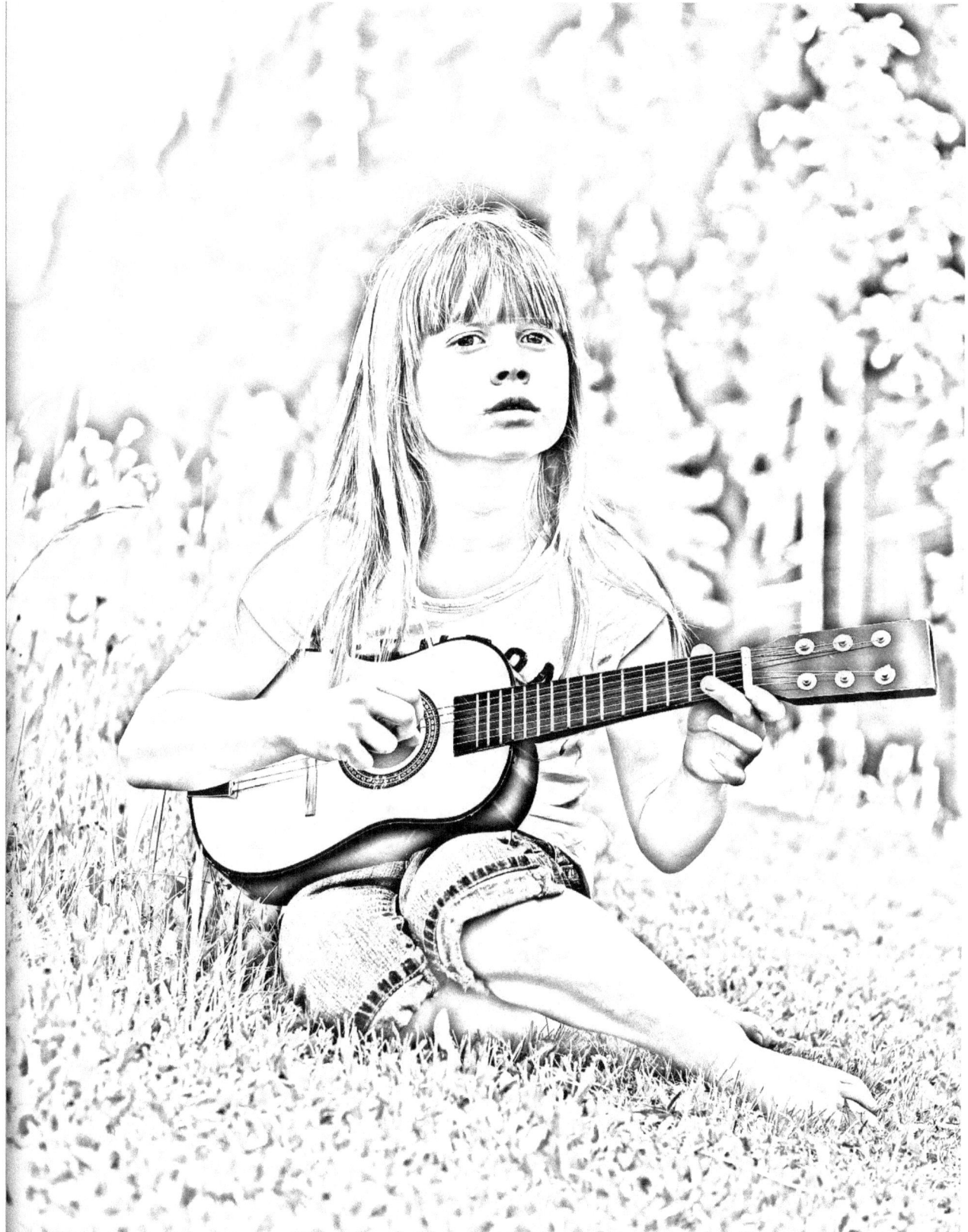

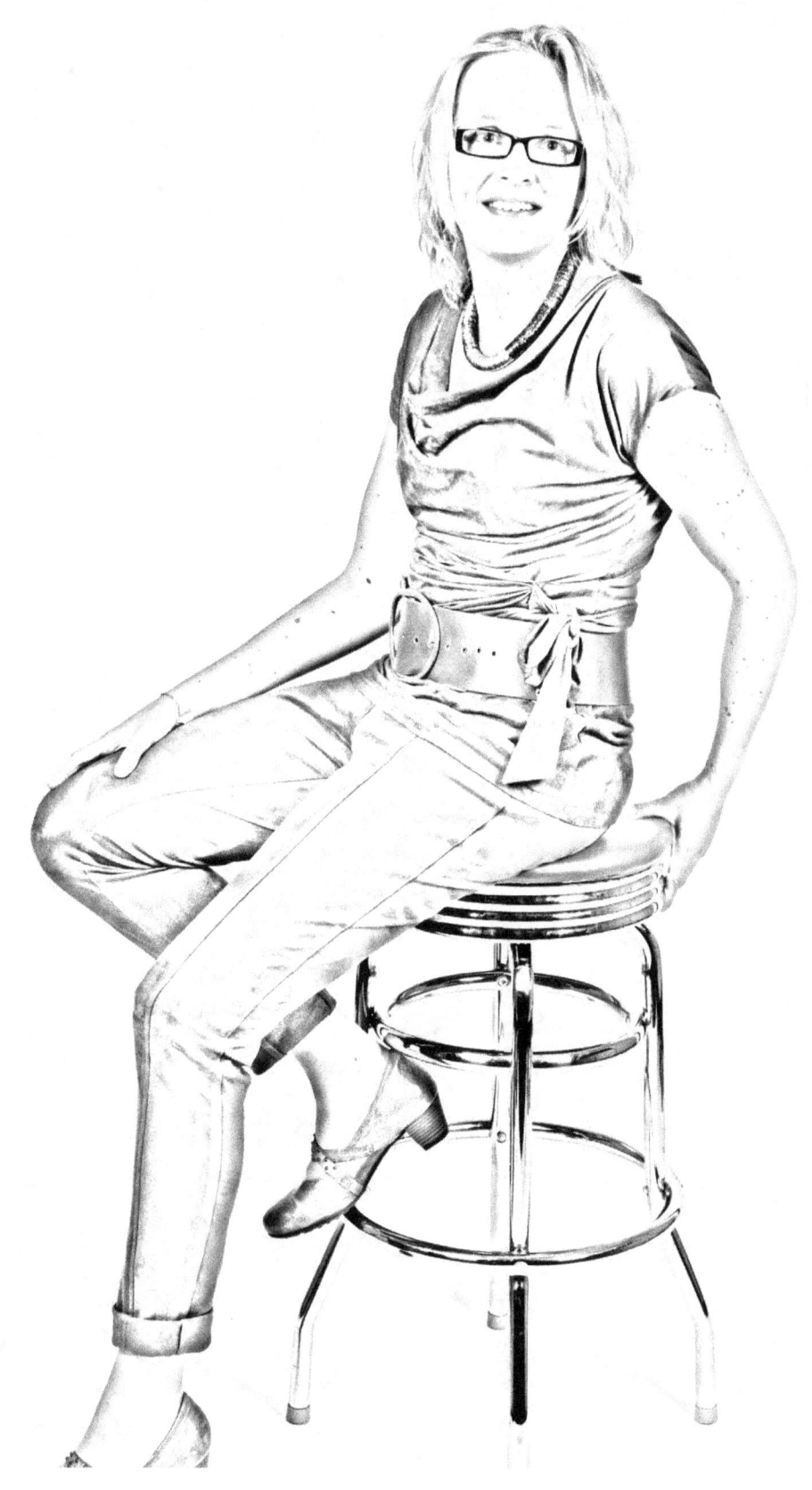

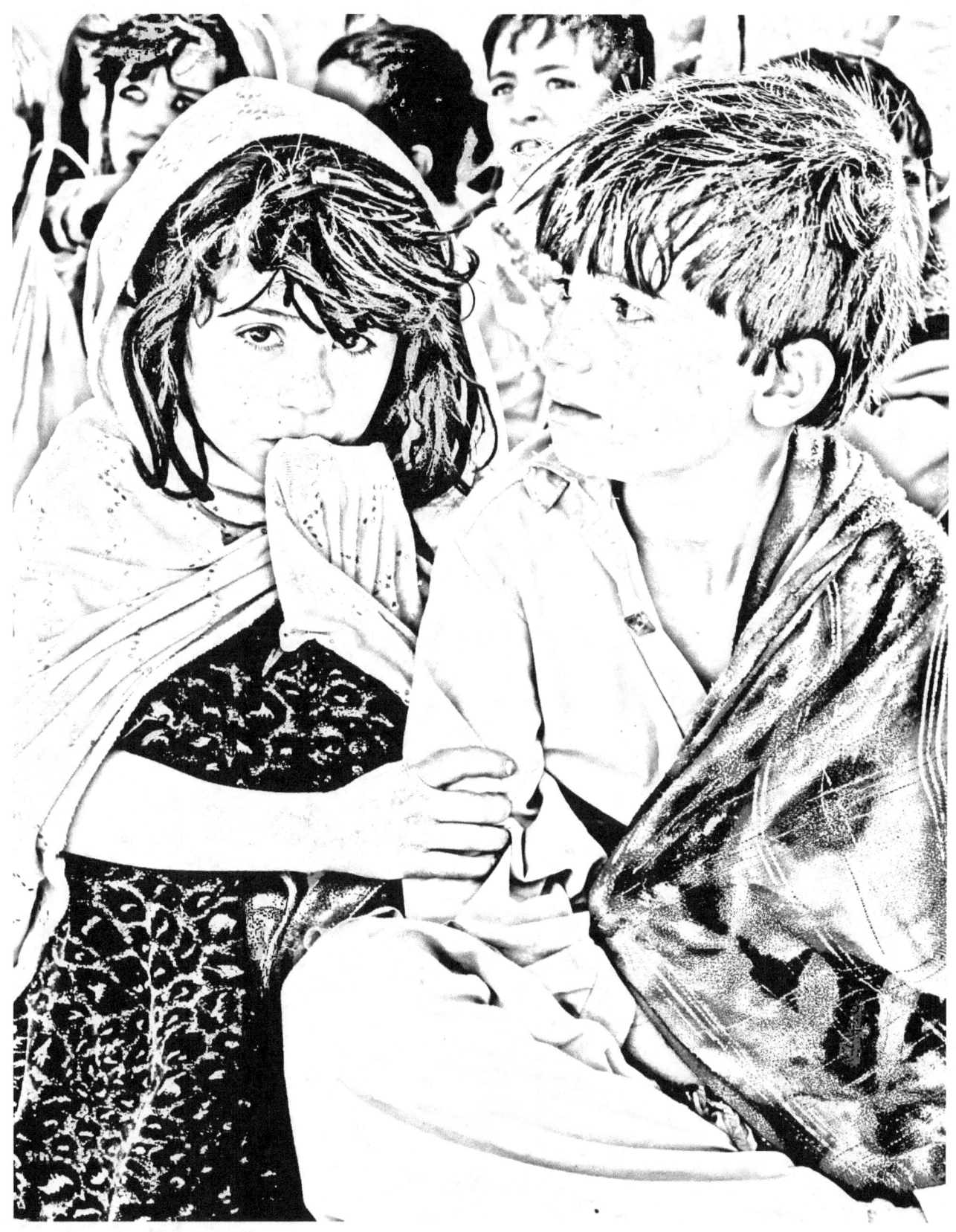

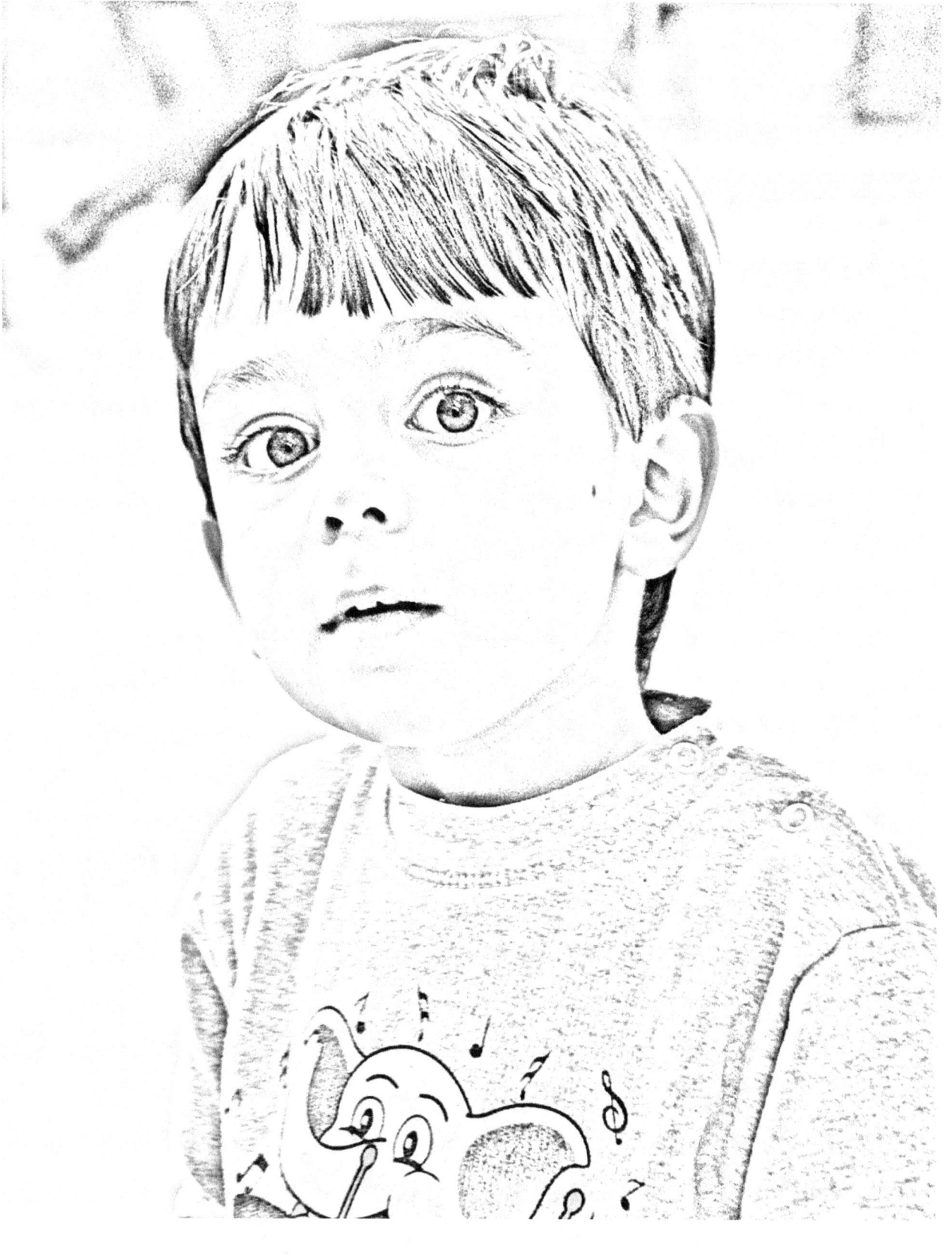

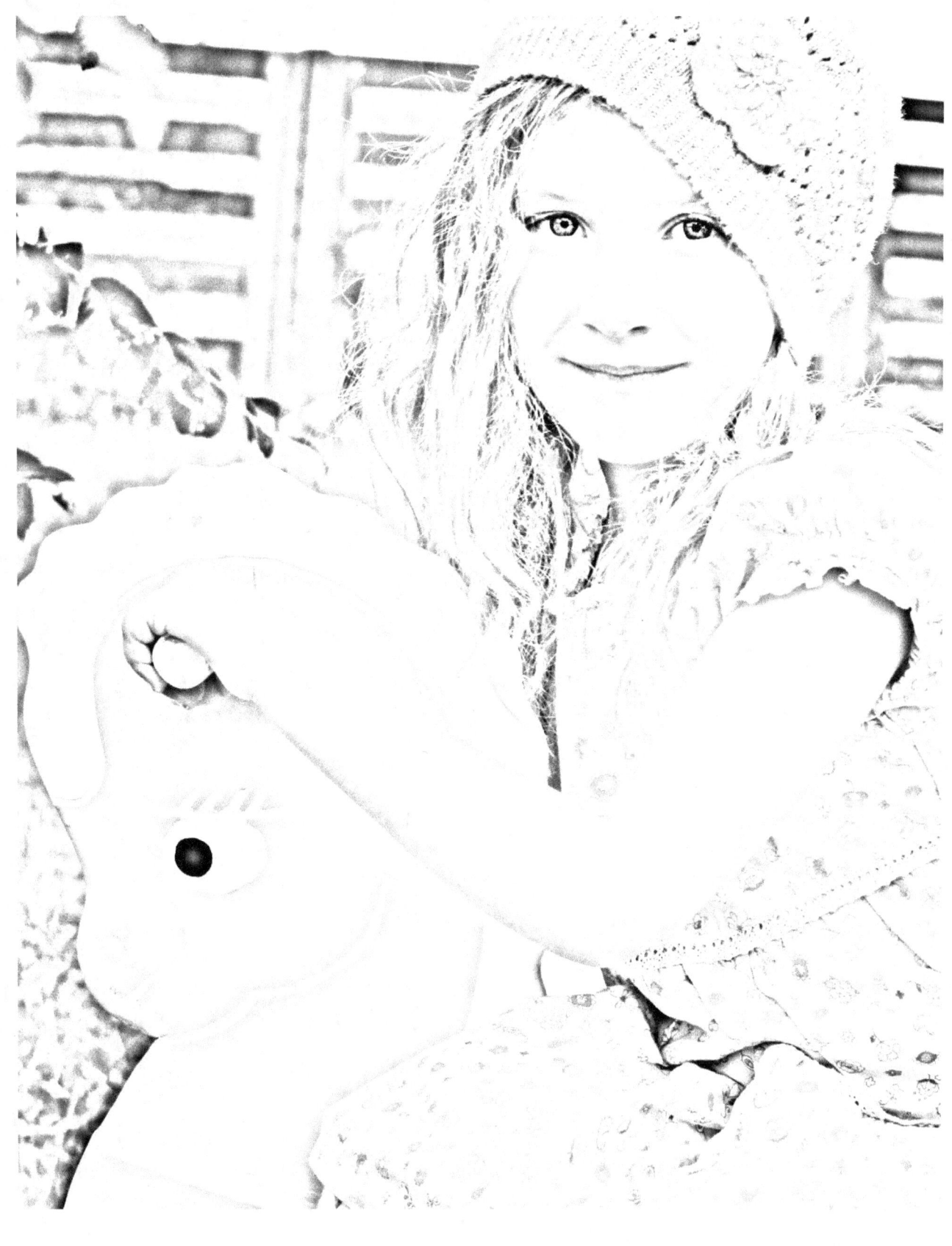

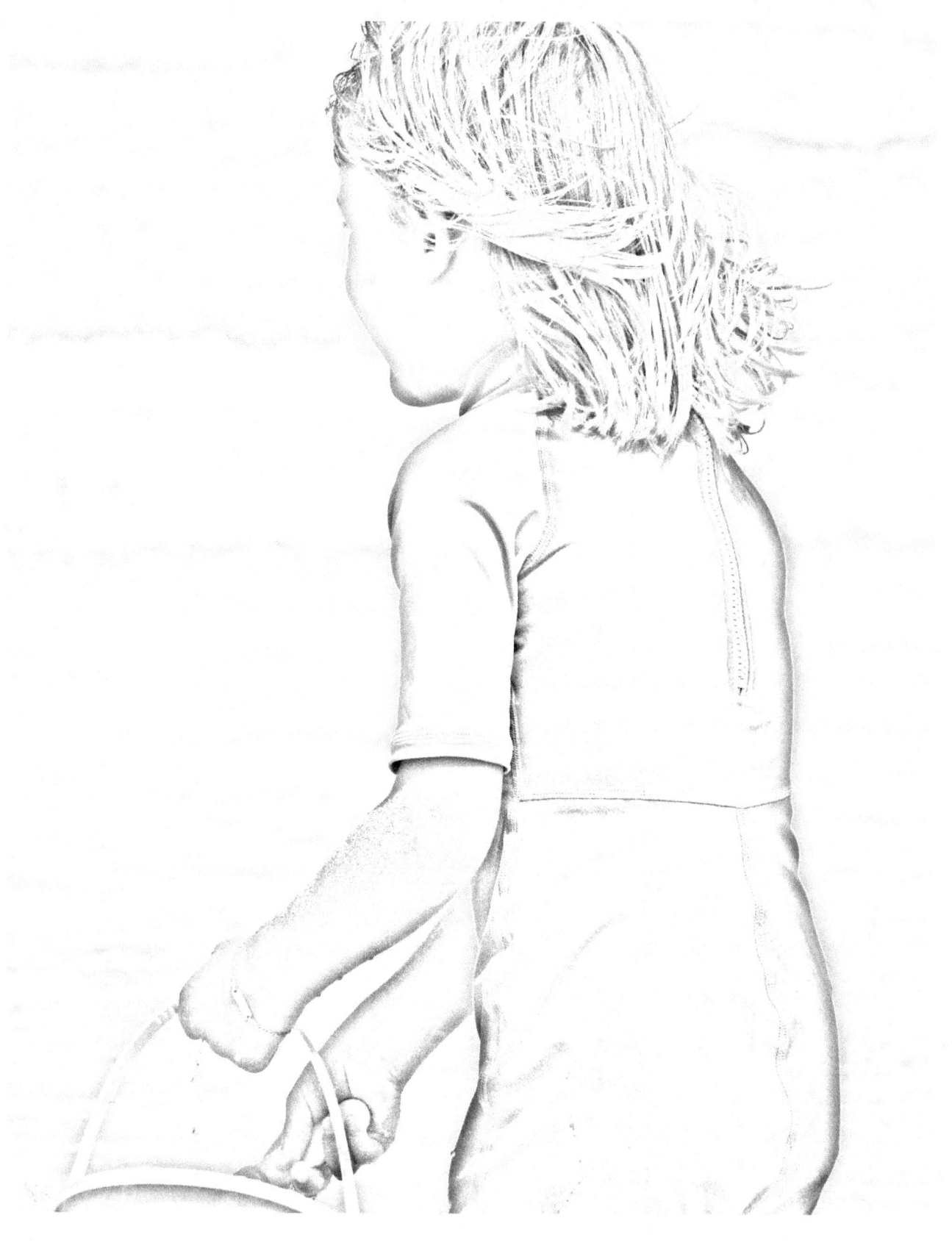

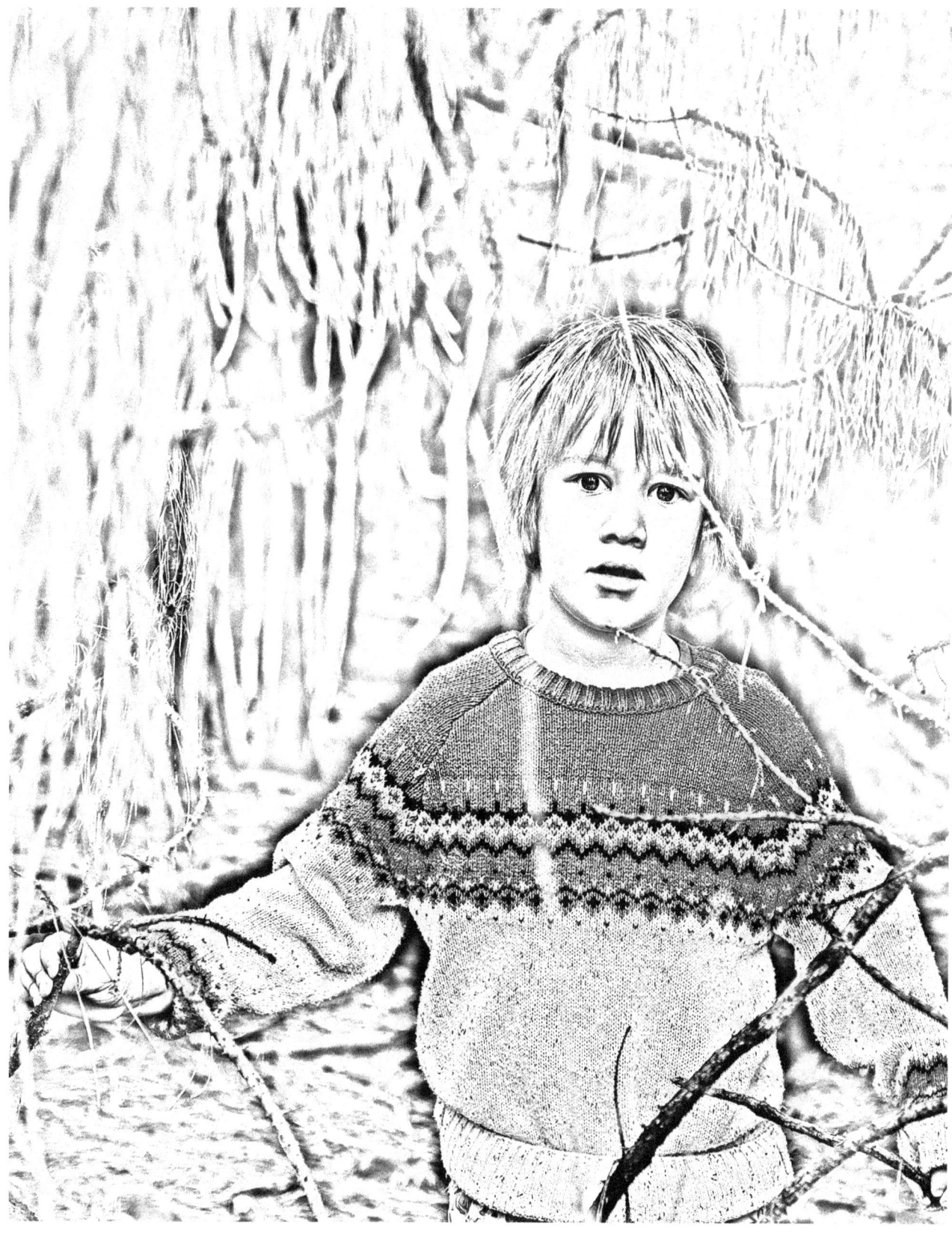

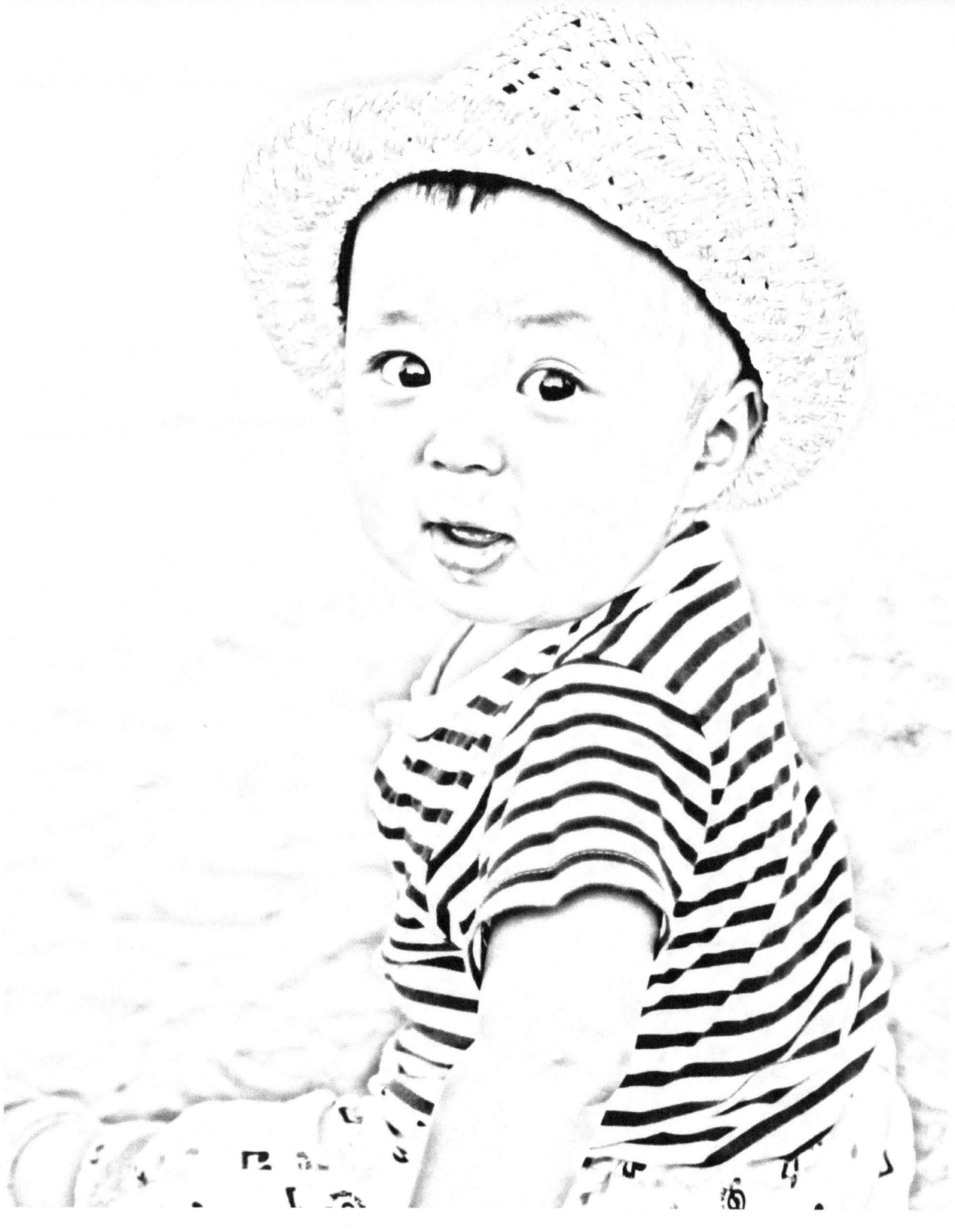

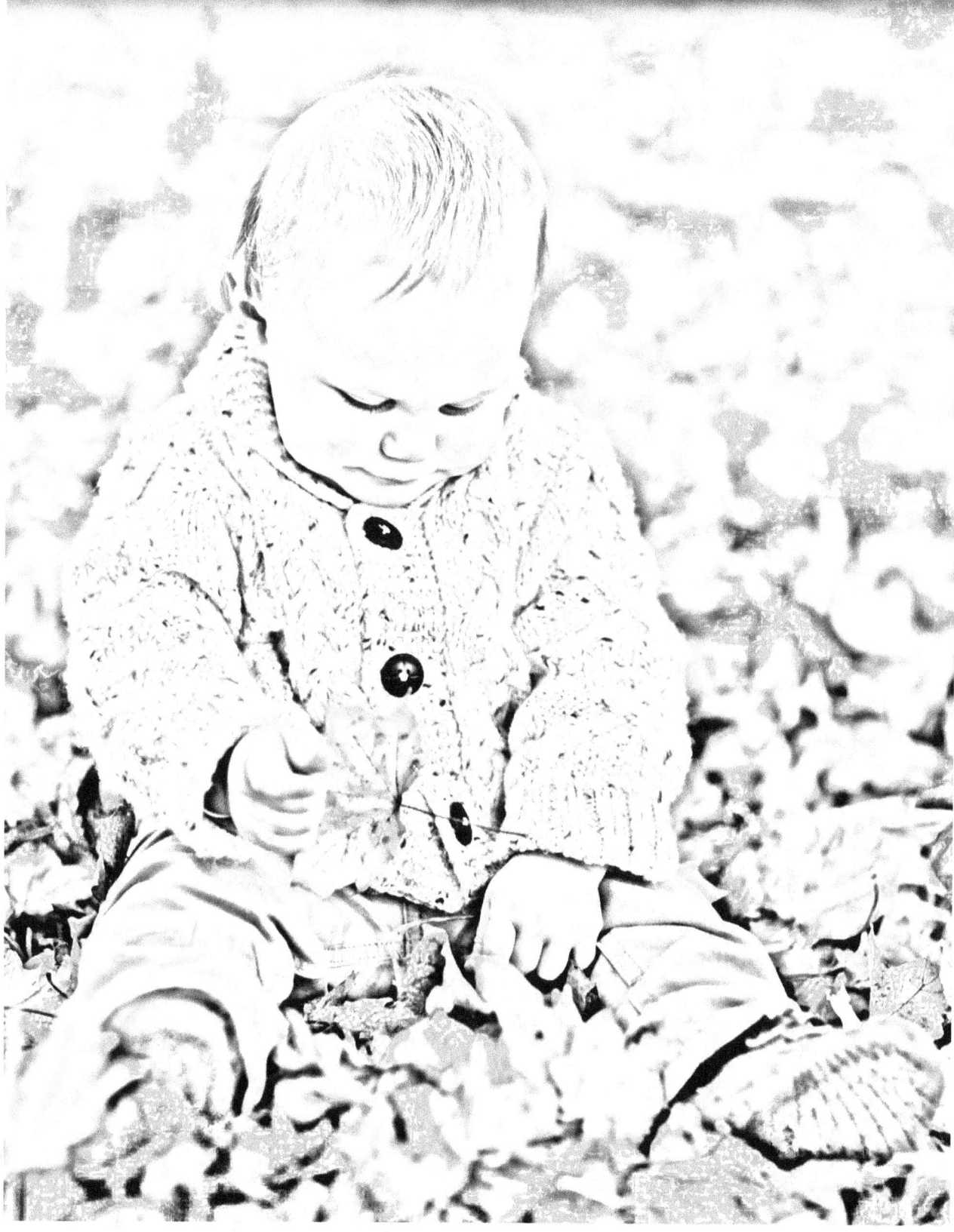

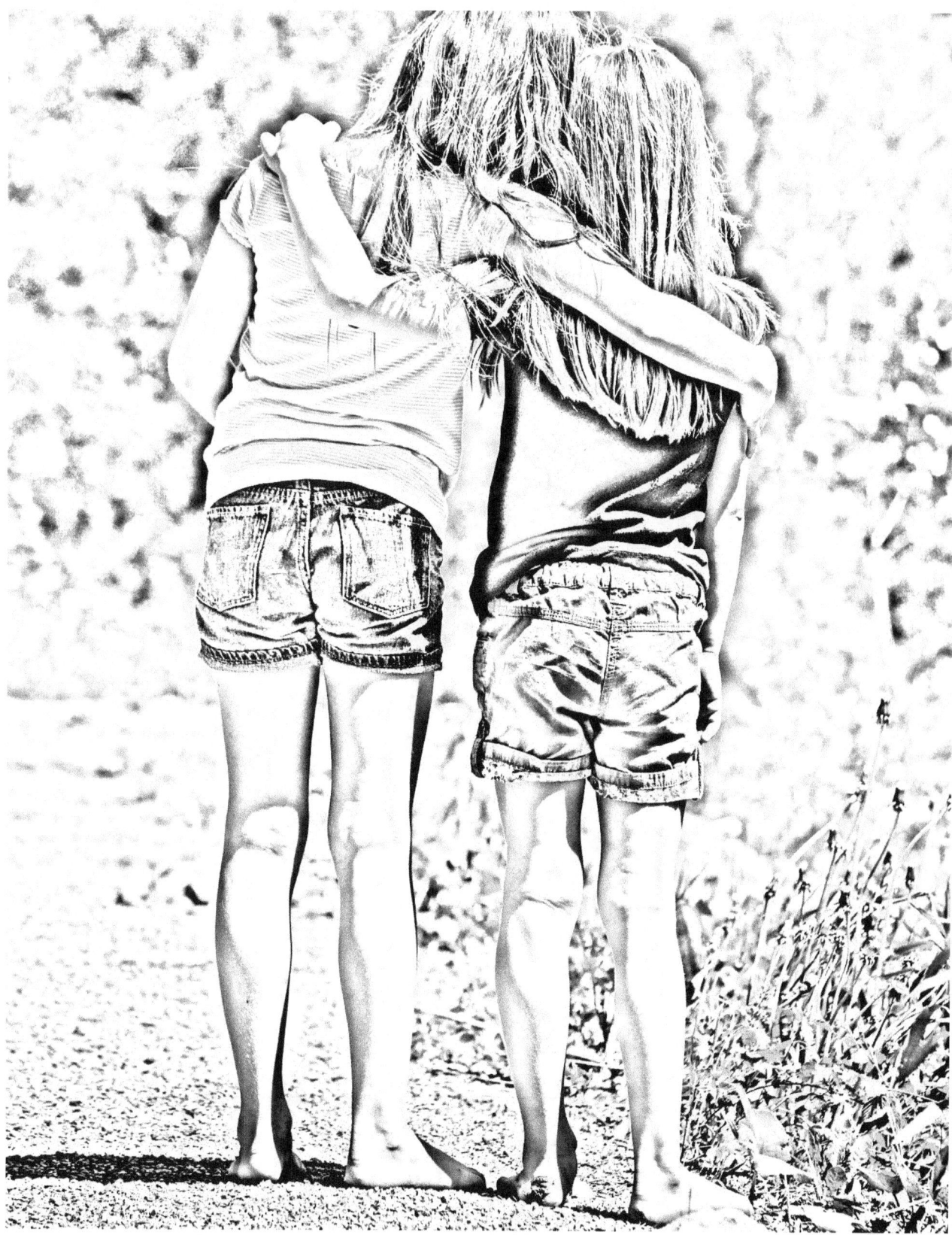

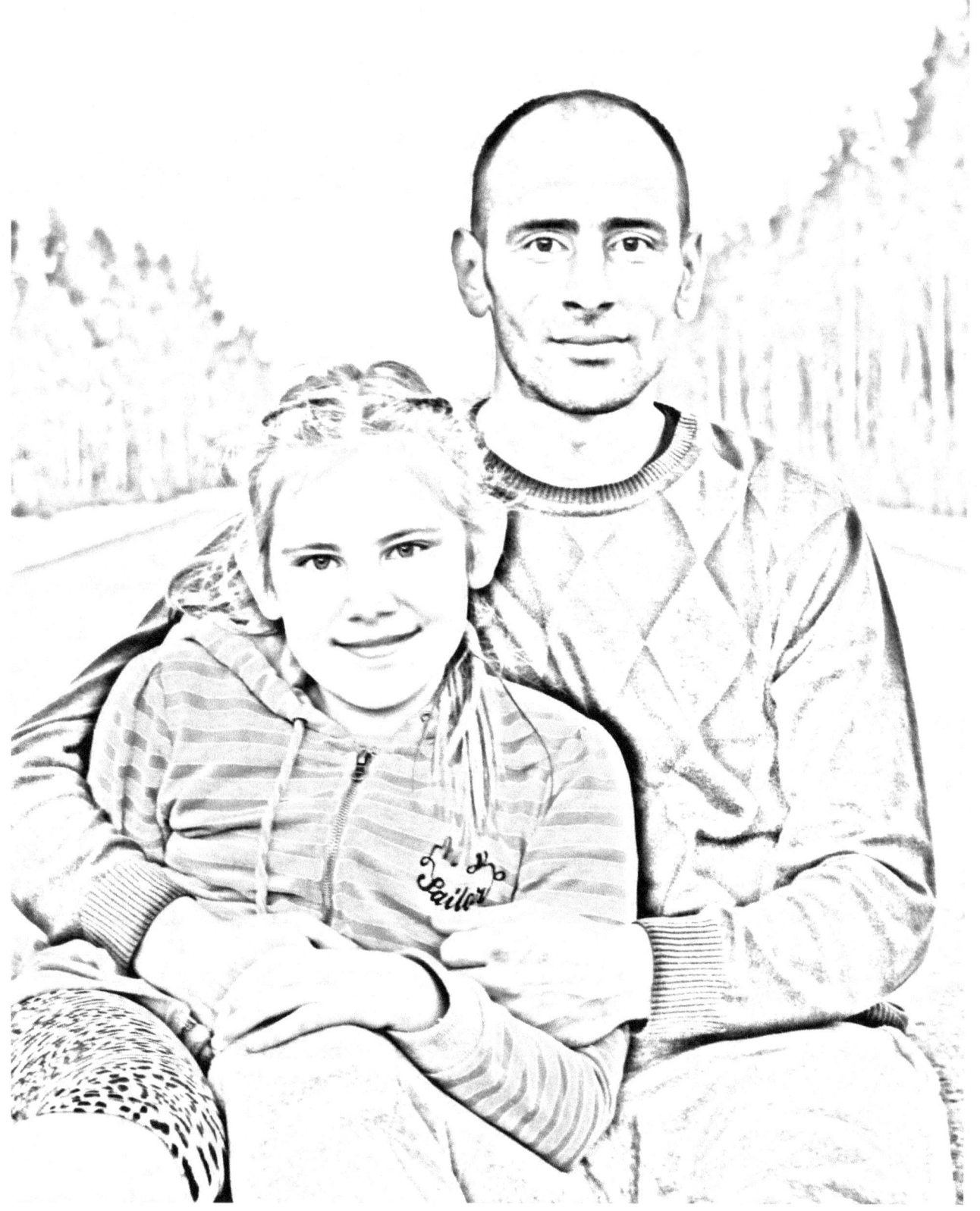

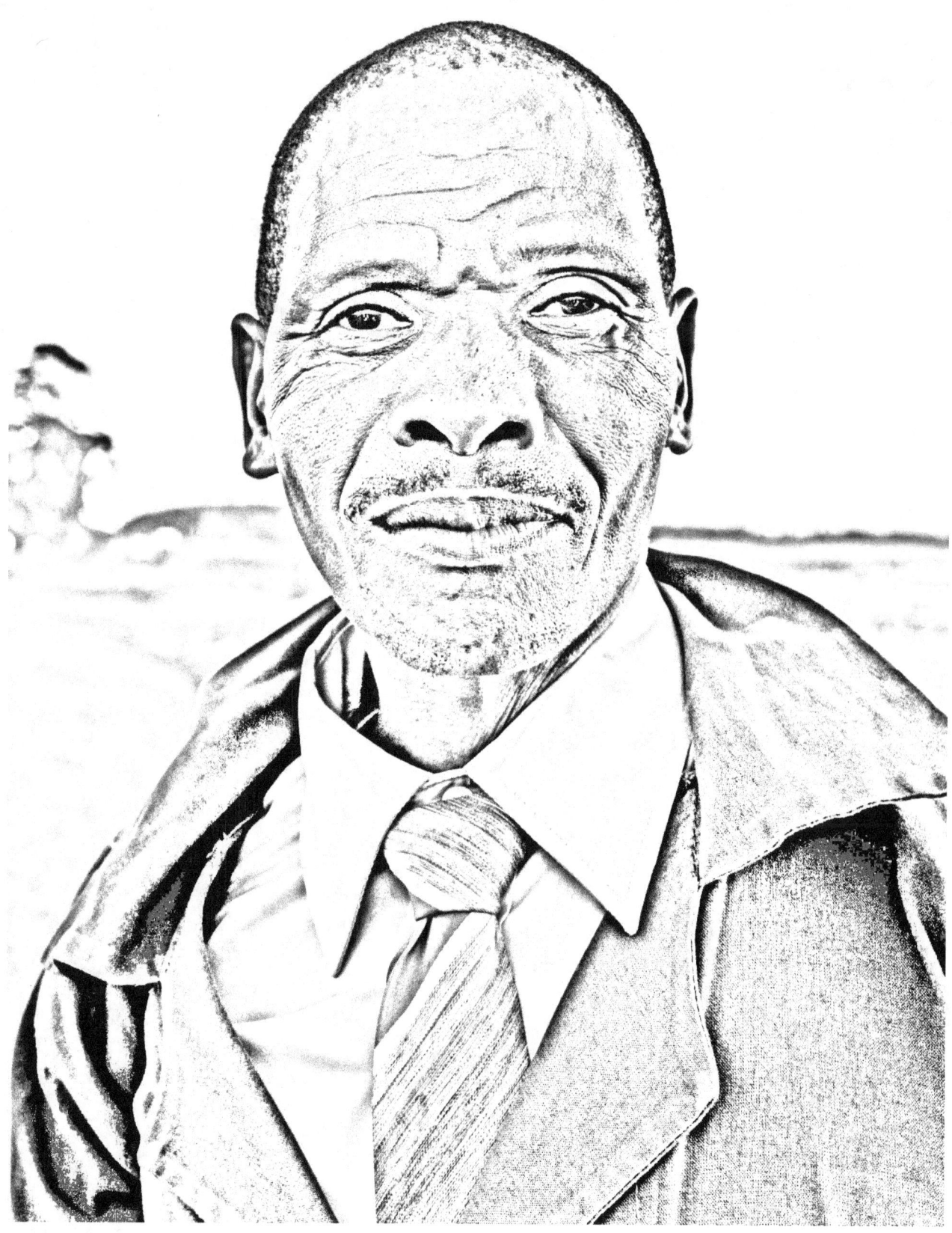

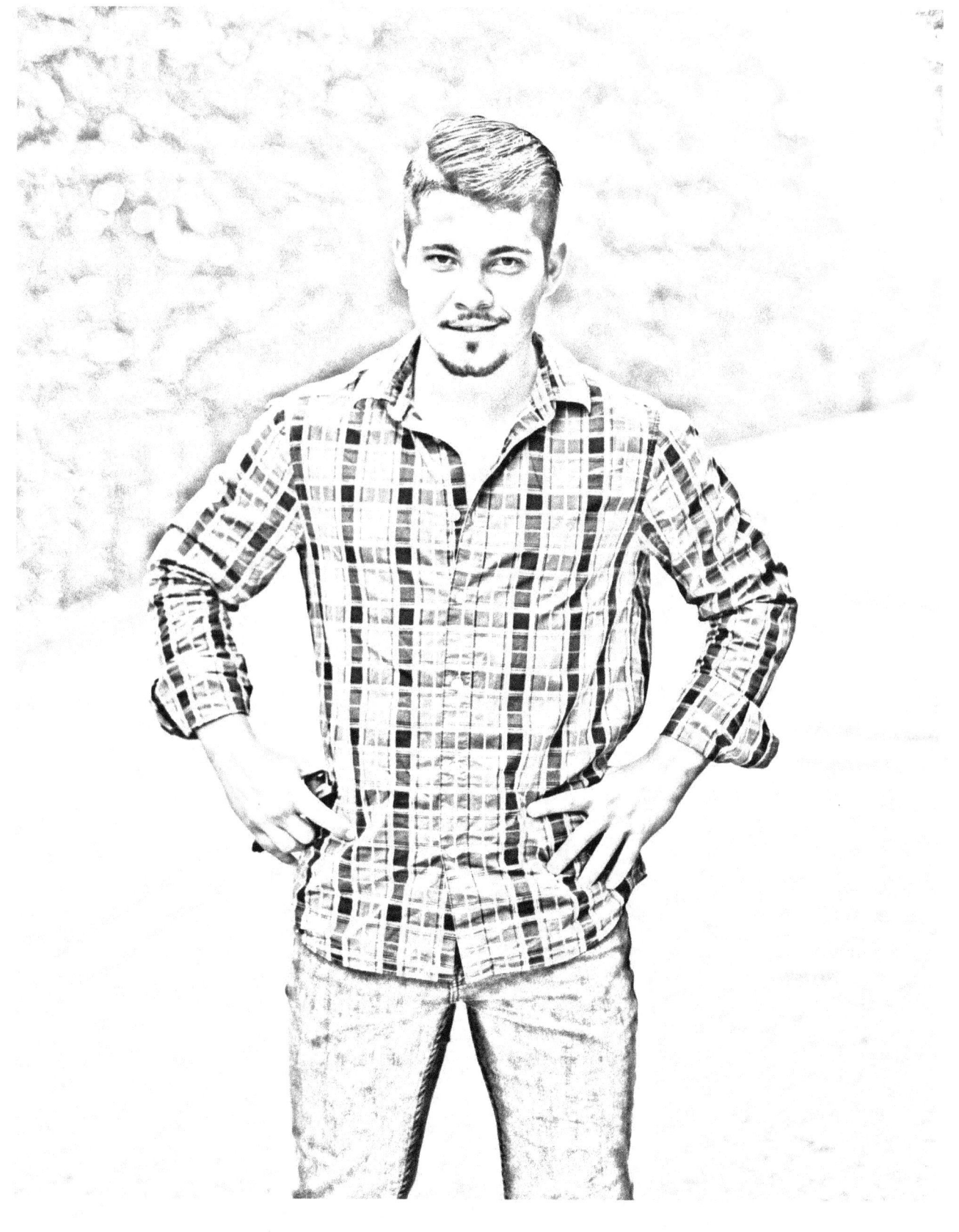

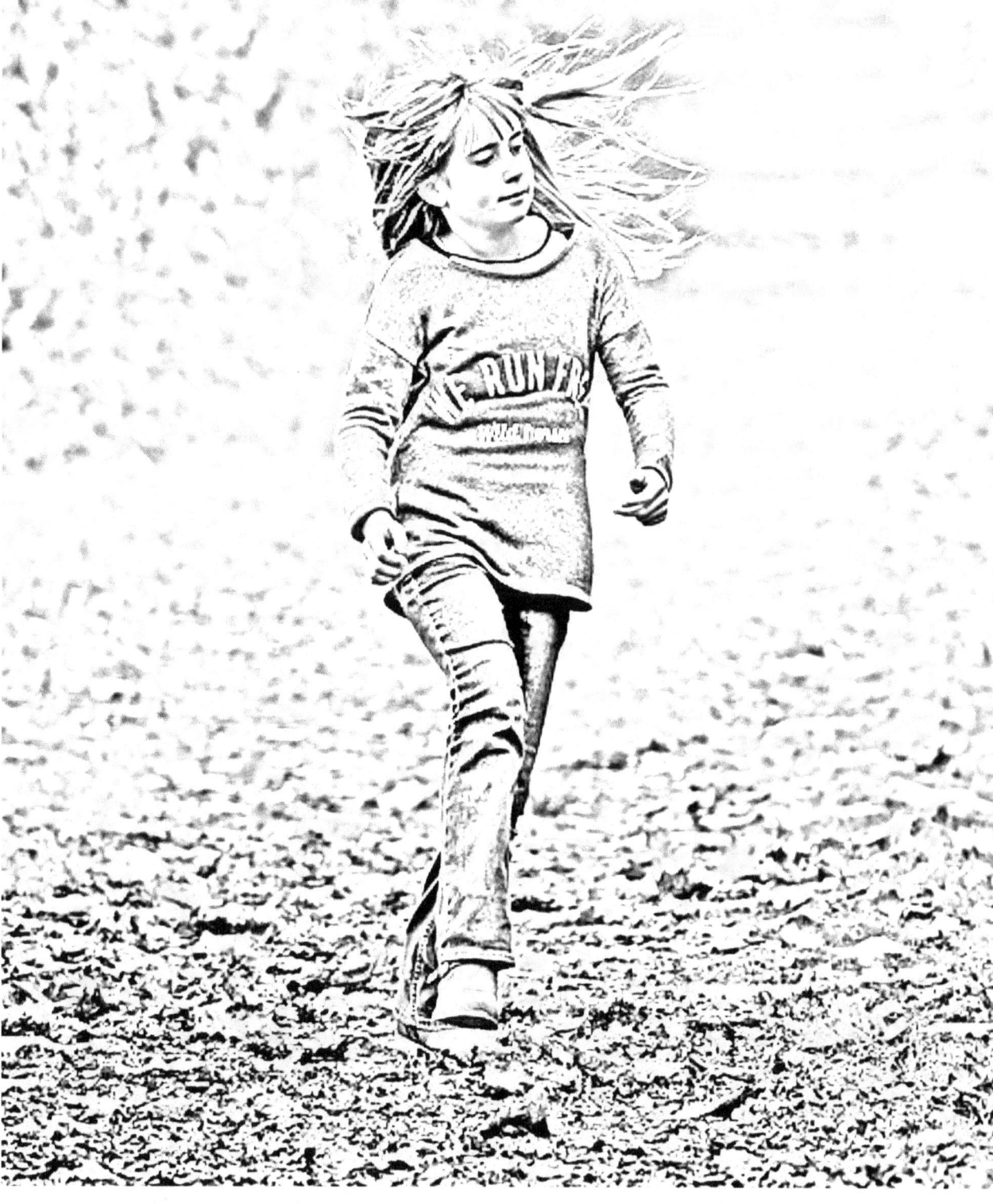

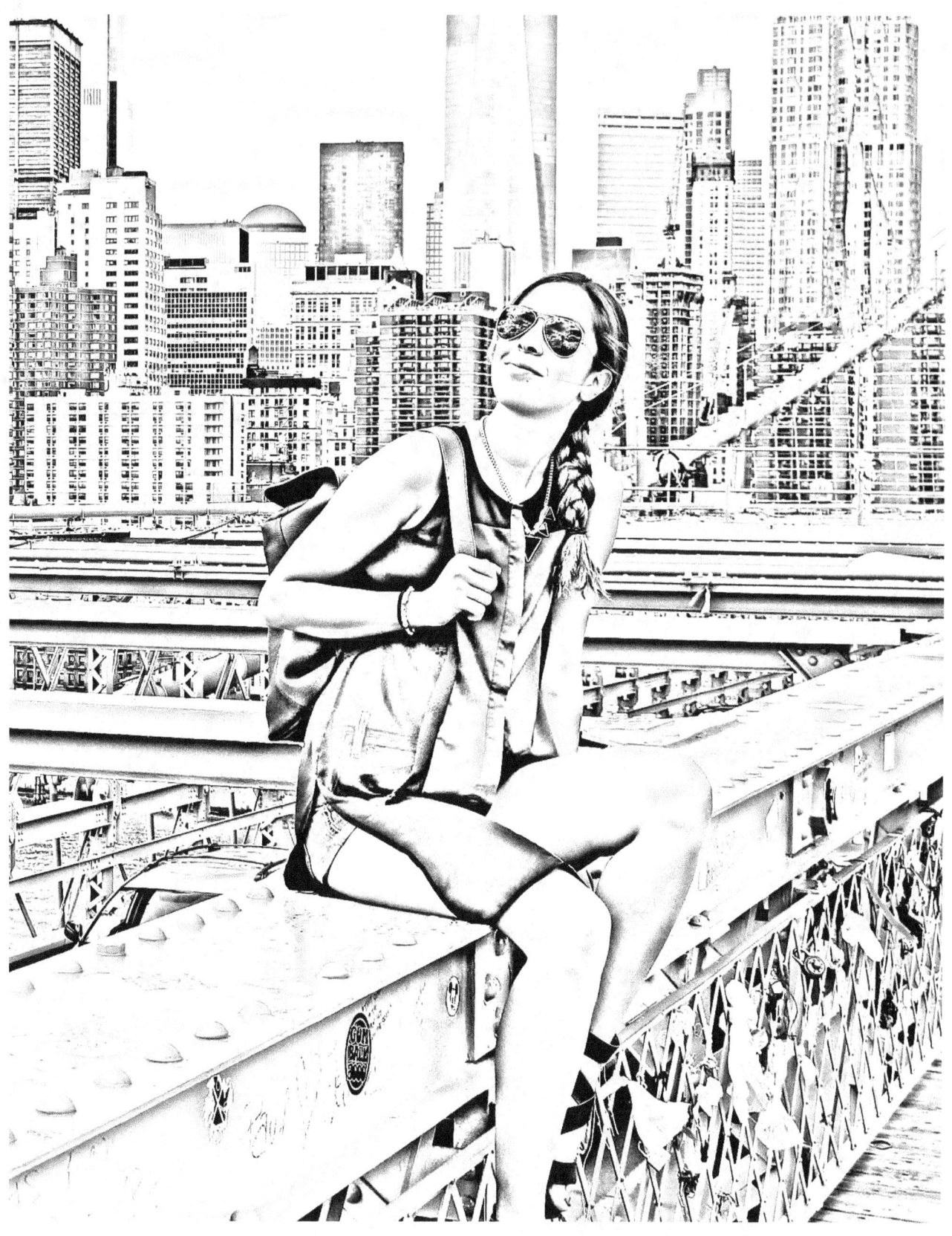

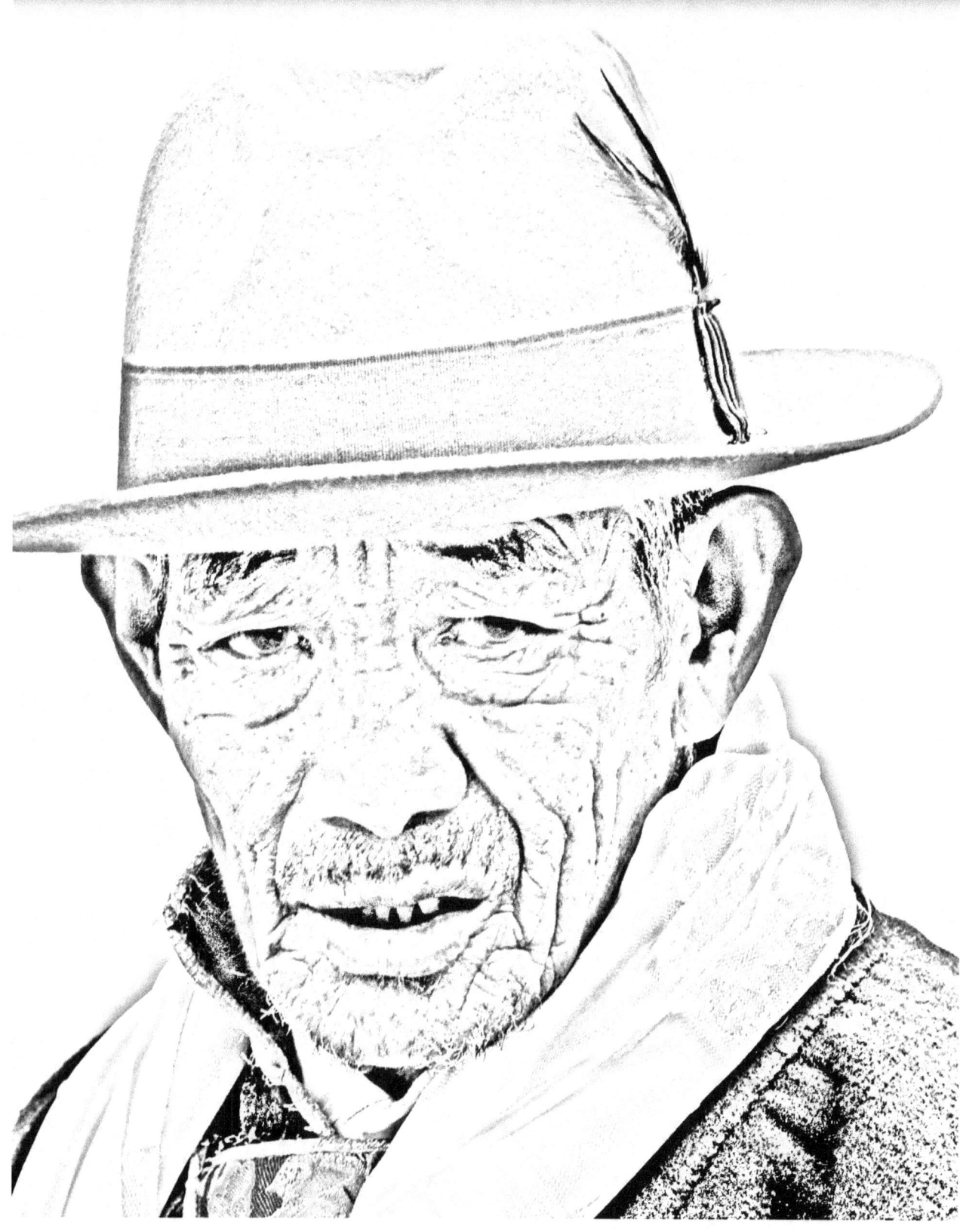

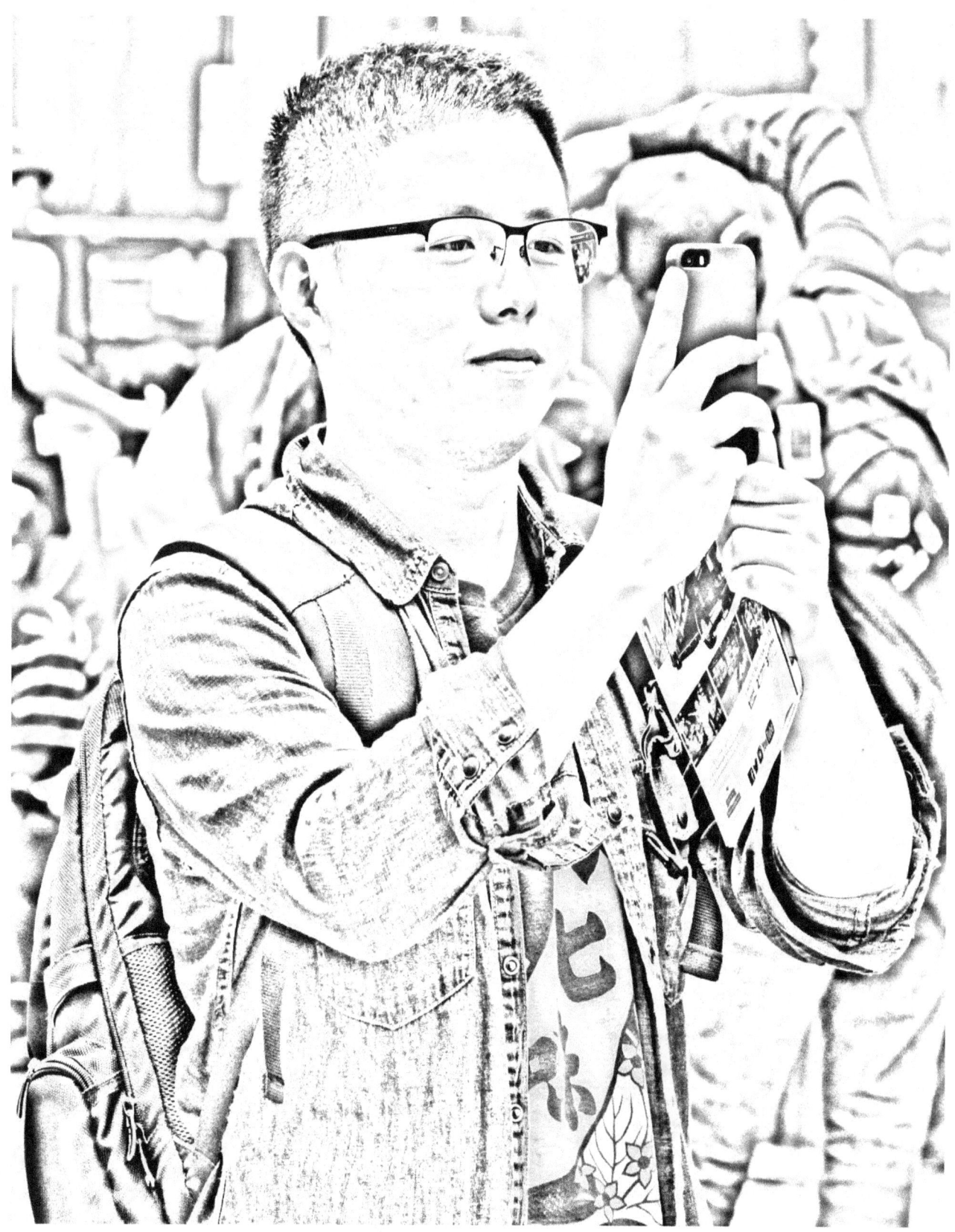

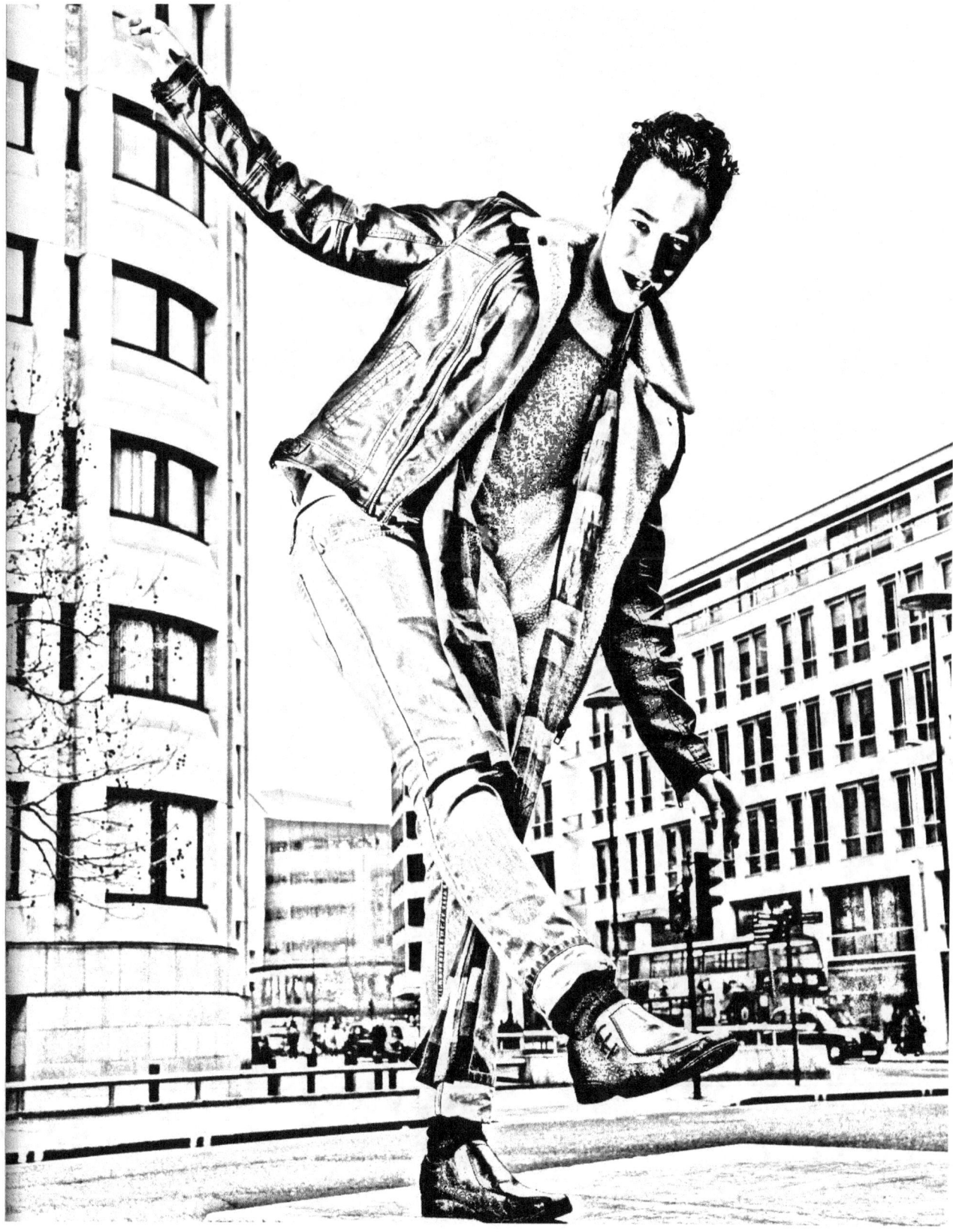

www.ingramcontent.com/pod-product-compliance
Lightning Source LLC
Chambersburg PA
CBHW081158180526
45170CB00006B/2138